D1163322

ANDRÉ KERTÉSZ

THE EARLY YEARS

ANDRÉ KERTÉSZ

THE EARLY YEARS

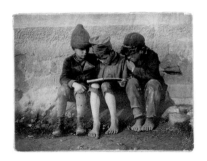

W. W. Norton & Company
New York London

INTRODUCTION

When I was invited to represent the Estate of André Kertész, I was astounded to learn that despite Kertész's fame, there existed a group of virtually unknown extraordinary early photographs over eighty years after they were created. This body of work, which remains primarily intact, is a remarkable collection of tiny prints known as the Hungarian Contacts.

Created during a thirteen-year period in Hungary (1912–1925), they show the first signs of Kertész's modern vision. Kertész was clearly experimenting with his camera, learning how to use film, light, and lens. We see the beginnings of his lifelong obsession with distortions and shadow. We witness the artist creating compositions that are strong enough to convey insight and emotion despite their tiny format. We also catch a glimpse of a playful side of young André Kertész, whose later work in New York (1936–1985) was known mostly for its melancholy cast. We sense Kertész's pleasure with the results and see his growing skill and daring.

This book and the exhibition it accompanies, the first solely devoted to Kertész's earliest vintage photographs, represent a rare opportunity for us to see the unfolding drama of the early years of this gifted artist. The following essay by Robert Gurbo, curator of the André Kertész Estate, provides invaluable insight into the evolution of creative genius. It also details the story of Kertész reclaiming these long-lost negatives and prints in 1963. Please share with me the thrill of rediscovering these works by this master of photography.

<div align="right">

Bruce Silverstein
Silverstein Photography, Fall 2005

</div>

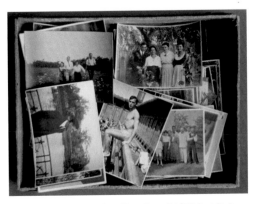

Hungarian contacts in box, December 1985 © Robert Gurbo

ANDRÉ KERTÉSZ
TINY PICTURES, BUT SHARP

ROBERT GURBO

From the perspective of a bereaved friend and associate, the weeks and months following André Kertész's death in the fall of 1985 were filled with turmoil. The task of disassembling his home of thirty-three years, high above the treetops of Washington Square Park in New York City, was no small undertaking. At times it felt like we were desecrating an artist's hallowed refuge. Since 1952, No. 12 J at 2 Fifth Avenue had evolved from an ordinary apartment into a sanctuary harboring clusters of meandering still lifes and convoluted tableaux—composed of objects, books, medals, papers, awards, photographs, and other works of art—which sheltered and nurtured one of the great artists of the 20th century. It was a fertile environment where André's close friends and admirers had spent years talking, drinking, and looking at photographs and it was sad to see it vanishing. It was also frustrating.

I could not ask André questions about what had just been uncovered. I could not tell him that I finally found his toolbox—the one he thought had been stolen—buried under other boxes in his closet. Soon the day came when solargrams emerged on the walls, outlines created by disappearing furniture and objects, signals of an inevitable conclusion.

Despite the sense of loss, each day also offered a certain mystery and adventure. Excavations of every nook and cranny in the apartment continually yielded new items and bits of information. Although I had known André's art for more than fifteen years and had worked with him in various capacities for the last eight (and was certainly no stranger to the apartment), there proved to be more that was unfamiliar than not. André had been a true hoarder, squirreling away almost everything that crossed his path. With each unearthed letter, document, or newly discovered photograph, the myth of André Kertész began to unravel and a new history emerged.[1] His life with his wife, Elizabeth, understandably, was much more complicated than he had ever professed. Among other documents alluding to marital friction, there were severed photographs (presumably cut by Elizabeth's hand) of the happy young couple attesting to a rift that Kertész chose to exclude in his romantic accounts. His glowing stories of life in Paris (1925–1936),

while still magnificent, dimmed a bit. Letters from André's family would reveal that André and Elizabeth's departure from their beloved City of Lights was more an act of economic desperation than an adventure. The full story of his failure to secure a top position in American photojournalism during his early years in New York would come to

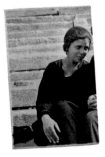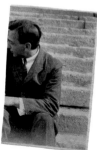

Untitled self-portrait with Elizabeth, September, 1921, cut apart

light. Ironically, all the documents he had saved would eventually reveal his share of the blame for his inability to find success. Even his most famous story—of being trapped with Elizabeth in the United States during World War II when his original plan was to visit America for a one-year sabbatical to explore new photographic material—would fall by the wayside.

Marta Acs, Elizabeth's sister and André's bookkeeper in his later years, provided timely assistance. She came to the apartment every day after André's death and helped to organize the early Hungarian

documents—translating and labeling early letters, diaries, inscriptions on photographs, and other artwork—all of which provided new clues to the full story of André's early years. This was an intriguing opportunity to be reintroduced to André Kertész, to be engaged in an intimacy of new dimensions made possible only by the artist's passing. André was no longer the ultimate arbiter of information regarding himself. I was now in a unique position to begin to trace the path of his genius to its origins.

Most rewarding, of course, in retracing the steps of an accomplished and complicated career, were the thousands of negatives, photographs, and contact sheets. Although André was generally quite organized, prints were scattered everywhere. They were in frames and in boxes. Some were in bookcases or inside envelopes with letters pertaining to the images. Others had served as bookmarks. It was a delicate scavenger hunt.

The photographs reproduced in this book were all taken in Hungary between 1912 and 1925. Most of them had rested in an unassuming corner of André's apartment for many years in stacks of small negative boxes that had once held his 4 x 5 glass plates from the 1920s and '30s. The boxes alone were charming, but their graceful period designs gave little hint of the treasures carefully nestled within.

These prints and negatives form the core of one of the great photographic archives of the 20th century. And like so many other important works of art, they did not emerge unscathed from the two world wars. Many photographs that André created while he was a soldier during World War I did not survive—André claimed that they had disappeared or were destroyed while he was separated from his company after being wounded and after his fellow soldiers had later been captured. Fortunately much of the material was safely back home.

These and others of André's artworks also barely survived World War II. When André and Elizabeth left Paris for America in 1936, he left many negatives and prints behind with a journalist and colleague, Jacqueline Paouillac.[2] Acting as his agent, she was to continue to make André's material available to the European market. During the war he lost touch with Paouillac. Evading the authorities, she had daringly left German-occupied Paris, surreptitiously transporting André's precious photographic cargo to a farm in La Réunion, a small village in the south of France. Many of the works she had with her were created by André in Paris as well as in Hungary. Some of the Parisian images, notably his experimental series of distorted nudes, would have been

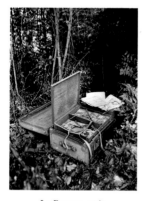

La Réunion, 1963

considered "Entartete Kunst" (degenerate art) by the Germans and discovery could easily have led to Paouillac's arrest and execution along with the destruction of all of Kertész's material.

Paouillac buried André's treasure in a makeshift bomb shelter, situated in a ditch between two buildings. It was not recovered until 1963, when Paouillac read an announcement in a newspaper of André's Parisian exhibition at the Bibliothèque Nationale and contacted him. The artwork was still in the ground when André arrived. He was ecstatic and documented the unearthing and examination of the photographs and glass negatives in a highly personal series of images that were not published during his lifetime.

In André's apartment I passed weeks in amazement, carefully removing more than one thousand of those very same little prints—some of which were no larger than postage stamps—from various boxes, spaces, and enclosures. Before me lay the development

of André's early years. Many prints had been destroyed, and a few had been removed and were out of André's control in later years, but what remained was the gold mine of his vintage Hungarian material. Although they had been loosely organized by subject matter within the boxes, many prints and plates appeared to be otherwise untouched since their recovery in 1963. There were hundreds of fascinating images that had never been reproduced, as well as many of André's classics in their original formats. After their retrieval and return, André enlarged many of these negatives, some for the first time since they were created. Often he would also reinvent them, cropping and reconfiguring the work to reflect his modernist leanings and evolving artistic vision. I was now looking at his raw material, his earliest efforts, and his original vision of Hungary, without his later editorial overlays. I was reading the earliest entries in his lifelong photographic diary.

André Kertész (born Andor Kertész) came from a lower-middle-class Jewish family in Budapest, Hungary, in the summer of 1894.[3] The middle of three boys, he grew up in a country prospering from a thirty-year hiatus from war and blossoming in a cultural and educational renaissance like no other in its history.[4] When André was fourteen

years old, his father died. The three boys continued to be brought up by their mother with the guidance of their uncle, a local businessman in the grain trade. André, whose interests were elsewhere, was admittedly a poor student who cared little for his studies and barely graduated from high school. Despite numerous attempts to secure employment, he spent a great deal of time in these early years in aimless pursuits, often tormented by the twin passions of his youth, romantic love and the arts. He was preoccupied, if not outright disabled, by an overpowering obsession—his melodramatic love affair with a young neighbor, Jolán Balog. Complicating matters, André's early search for an outlet for his creativity was hampered by his need to contribute financially to his family. During this period he often exhausted himself, vacillating wildly between the exhilaration of romance and an overwhelming sense of worthlessness.

In early diaries André chronicled his visits to museums, to the theater, and to readings in contemporary literature. Writing in 1912, he lamented his inadequacy to judge or evaluate art because he filtered all that he viewed through his own personality and "looked for the poetic in everything."[5] Many years later he and an appreciative art world would regard this sensibility as one of his greatest gifts.

André, along with his younger brother, Eugenio (Jenő), began photographing in 1912. They had received a camera as a shared gift just before André's graduation and were equally fascinated with the photographic medium. The boys experimented with the camera on weekends, during vacations, and after work. Many of the early photographs are simply of family gatherings on the porch or out in the countryside, yet within this period André also created a number of images that would later be considered among his masterpieces.

At first, without an enlarger, the brothers made only contact prints. In a 1912 diary entry, André describes one of these prints as a "tiny picture, but sharp," which he "could stare at endlessly."[6] In later years André would often advise aspiring photographers to "simplify, simplify, simplify." This mantra was no doubt, in part, the result of his early experiences of working with such small images. André resorted to viewing his subjects as geometric shapes and forms in order to impart a visual strength to the resulting prints through the use of abstract design. This skill, born of necessity, would evolve to underpin his early connections to the modernist movements in Paris.

André's abilities were developed and broadened in the crucible of war. But when drafted into the Austro-Hungarian army in the fall of

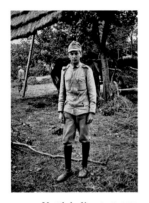

Untitled self-portrait, 1914

1914, still tormented over his love for Jolán, he first saw his situation as an opportunity to end forever his constant anxiety and distress. He wrote, "I want to be rid of myself, but not through my own hand. . . . I want to be annihilated there."[7] Despite this despondent state, André carried his camera in his backpack and frequently photographed his fellow soldiers as well as the towns and people he encountered. In December his brother Jenő sent him an Ica Bébé box camera.[8] Although quite cumbersome by today's standards, it was smaller than most other cameras used at the time. The camera accommodated a magazine of several 4.5 x 6 cm glass plates, enabling one to photograph continuously without having to change large film holders with heavy glass plates for each exposure. The camera could also be handheld (it had an f-stop of 5.5, considered to be fast at the time), providing the opportunity to work without a tripod and allowing the artist to maneuver swiftly. With this tool, André created many eloquent photographs—emotional responses to the

horrible effects of war on the lives of the soldiers, their families, and other civilians, sometimes depicting their struggles for survival.

In a 1982 interview, while remembering one such powerful image, *Forced March to the Front* (plate 13), André recalled the following:

> This was on the Polish front, a part of our regiment was captured by the Russians and it was important to replace them and then we walked 48 hours. Practically without sleep—we slept a few minutes standing, or urinated, or I don't know what. We had two bites, and marched, marched. I stepped out of the line, took the picture, and marched on. I am one of the many. . . . I captured this. I saw how beautiful it was. . . . I stood out and took the picture—and it worked. It includes everything.[9]

In *Untitled, 1914–1918* (plate 20), we see the skeleton of a boxcar that has been ravaged for firewood to keep the troops warm. In *D. Minna Horn, July 26, 1918* (plate 15), Kertész documented the importance of the horse to contemporary warfare, as we see the exposed soldiers transported, without cover, on the deck of a ship while the horses are carefully sheltered below. In *Red Hussar Going to*

War (plate 17), we witness an intense, intimate exchange between a departing soldier and his anguished family.

André's facility in designing and expediting these images matured rapidly. His patience, restraint, and confidence of execution—abilities he developed in response to the exigencies of war—would continue to serve him throughout his life. Although André later claimed that he always sought to photograph events reflecting everyday life, he was also taking some direction from editors and publishers of the burgeoning newspapers and magazines of the day. Through contests, they solicited photographs documenting the lives of the soldiers. Kertész would send his unprocessed glass plates back to Jenő with instructions to develop the prints for the media and to forward copies to him at the front for distribution to the other soldiers and officers.

The war years were difficult for André. First he contracted typhoid. Then, in 1915, he was shot and wounded. After being hospitalized and receiving experimental treatments, he would swim every day as part of his convalescence. It is here that he discovered and recorded his first "distortion." Sitting above the pool in the bleachers, he observed and photographed the rippling effects of the moving water that refracted his vision of the swimmers as they cut through the pool's surface

(*Underwater Swimmer, Esztergom, Hungary, 1917*, plate 28). This altered state offered a visual paradox. A somewhat deformed, headless body is gracefully gliding through the frame—a hopeful metaphor of man, battered by war, somehow managing to *progress*. This early picture became a seminal image in André's lifelong search for what he called "natural distortions."

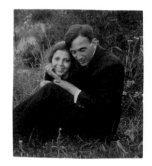

Untitled self-portrait with Elizabeth, June 8, 1921

André was released from the army in 1918. Under pressure from his family, he continued a fruitless search to find suitable employment. While working as a financial clerk, André met Elizabeth Salamon (born Elrzsébet Salamon), an amateur artist whom he would later marry in Paris in 1933.[10] Despite André's tendency to be consumed by romantic melodrama and to be overwrought by his intermittent bouts with a sense of inadequacy, the couple's mutual interest in the arts sustained their relationship.

Back home and in search of community, André participated in photography contests and contemporary photographic clubs, and even

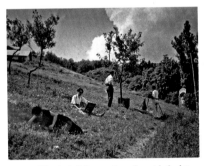

Elizabeth Salamon, Imre Czumpf, André Kertész, and Rezső Czierlich, 1924

worked briefly with Pál Funk Angelo, a professional photographer and successful entrepreneur with studios in Nice, Budapest, and Paris. Of greater significance, he befriended a circle of artists that included the successful and influential Istvan Szönyi and Vilmos Aba-Novak.[11] It was his exposure to this group—which included some of Hungary's most talented and forward-thinking painters, designers, and sculptors, and with whom André shared outlook as well as subject matter—that influenced and reinforced his understanding of the design and geometry of his own art. At the same time there was a general reverence within the art community for the cultural traditions and rural ethos that had sustained Hungary for generations. This respect found expression in the many beautiful photographs André executed in both rural and urban settings. A number of prints made in the countryside pose an elegant

balance between his unabashed affection for the pastoral and an increasing commitment to the modern (plate 11).

In the art community, these shared philosophies of beauty and design also resulted in exultant explorations of the human form, celebrated by many European artists in the wake of, and as counterpoint to, the Great War and its wanton destruction of life

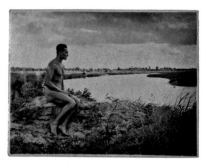

Jenő Kertész, Dunaharaszti, Hungary, May 30, 1920

and limb. Here André made wonderful use of his brother in a series of nude studies in the countryside. These photographs perform a dual role. They serve André's desire to create archetypal images about man's integration with nature, and they underscore the powerful role that Jenő played in this complex fraternal relationship. At times Jenő was no more than a prop or a model used to represent an idea or concept, such as when André depicted his brother as a *scherzo* (plate 42) or in mid-jump representing an airborne Icarus. Other pictures are

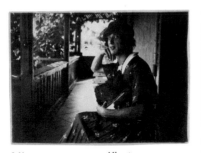
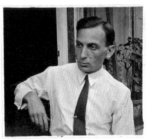

Self-portrait as a woman, Albania,
July 23, 1921

Untitled self-portrait

pure, sensitive portraits reflecting André's love for the man whom he
later described as his "perfect collaborator."[12]

The numerous self-portraits in his oeuvre, also influenced by the
circle of artists surrounding Szönyi and Aba-Novak, reaffirm the fact
that André saw himself as part of the story he was telling in his
pictures. He went to a local machinist and ordered a primitive self-
timer that he attached to his camera. He would insert himself into the
image as a participant-observer, watching the exposure occur while
sitting among the other subjects, who were sometimes aware of his

picture making, and sometimes not. At other times, he assumed various roles: a businessman, an artist, a farmer—even disguising himself as a woman as he sat on a porch. Despite the insecurities he professed in his literal diaries or perhaps because of them, he often projected a knowing expression, seemingly confident of the continuing exploration for self in much of his imagery. In later years, this self-examination expanded to include original metaphors ranging from pigeons to wilted tulips.

Although André managed to construct a fragile patchwork of support that nurtured him as an artist, he never found meaningful employment in Hungary. His lingering self-doubt, combined with the pressure from his family and his desire to prove himself to Elizabeth, clouded his awareness of the powerful body of work that he had already created. It was only after Elizabeth harshly confronted him in an argument, professing that she would withhold her love for him until he made a life for himself, that he was compelled to leave Hungary in 1925 in search of his as yet to be defined career as a photographer.[13] Insecurities aside, the body of work amassed in his native land was ample evidence of the talent and skill that would soon propel him to stardom in Paris. His early technical experiments in night photography, his intense exploration of portraiture,

the exquisite timing and execution derived from his war years, his delicate sense of form, and the lessons learned from interactions with the community of artists all provided him with the tools necessary to pursue his goals. Many years later, with his stature as a world-class artist secure, André Kertész revealed that he had come to fully appreciate the vital importance of this early period to his entire career when he confessed, "All that is treasured in my life had its source in Hungary."[14]

Notes

1. For an in-depth analysis of André Kertész's archival material and Kertész's entire career see: *André Kertész* by Sarah Greenough, Robert Gurbo, and Sarah Kennel, (Washington, D.C./Princeton, NJ: The National Galley of Art/Princeton University Press, 2005).
2. It is unknown which negatives and prints were left behind when Kertész left France for America, as documents indicate that he did bring much of this material with him in 1936. André also did meet with Paouillac while on an assignment in Europe in 1948. It is unclear why André did not arrange to ship the materials back to the United States at this time. However, it would have been quite costly and, with his career as a photo-journalist in shambles, it is possible that the material would have been of little use to him at the time. It is also possible that he was considering returning to Paris in 1948.
3. Andor Kertész was born July 2, 1894. He changed his name to André after he arrived in Paris in 1925. For continuity in this essay he is identified as André Kertész.
4. For further discussion of this period, see John Lukacs, *Budapest 1900: A Historical*

Portrait of a City and Its Culture (New York: Grove Press, 1988), and Thomas Bender and Carl E. Schorske, eds., *Budapest and New York: Studies in Metropolitan Transformation, 1870–1930* (New York: Russell Sage Foundation, 1994).

5. Kertész diary, January 28, 1912. Kertész kept extensive amounts of archival material. The original documents are at the Kertész Archive, Mission du Patrimonie Photographique, Paris, with selected copies at the André and Elizabeth Kertész Foundation, New York. Kertész's diaries and correspondence were translated by Bulcsu Veress in preparation for the catalogue *André Kertész*.

6. Kertész diary, June 24, 1912.

7. Kertész diary, October 25, 1914.

8. Jenő Kertész to André Kertész. In a letter dated November 17, 1914, Jenő writes to André: "The machine I mentioned on the postcard is Ica Bébé. With plates, 6 cassettes . . . I believe this would be better, as its lens is outstanding, very fast (f:5.5). Just the machine for you. You could take snapshots in overcast weather, even in a storm." In Kertész's diary on December 12, 1914, "The little machine arrived."

9. Krisztina Passuth, "Párizsi beszélegetés André Kertésszel," *Új Művészet* (June 1994): 74–76. Translated by Bulcsu Veress.

10. For continuity in this essay she is identified as Elizabeth Salamon.

11. For an in-depth discussion of Kertész's interaction with other artists during this period see: Sarah Greenough, "A Hungarian Diary 1912–1925" in *André Kertész*, Sarah Greenough et al., pp. 11–23. Also see Oliver Botar in Oliver Botar with Phileen Tattersall, *Tibor Pólya and the Group of Seven: Hungarian Art in Toronto Collections 1900–1949* (Toronto: Justina M. Barnicke Gallery, Hart House, 1989), pp. 38–39.

12. Passuth, pp. 15–21.

13. Kertész diary, July 10 and 24, 1924.

14. Sylvia Plachy, "Hungary by Heart," *Artforum International* 24 (February 1986): 90.

* Plates 13, 45, and 51 from 8 x 10 later print

Camera in Landscape, 1918–1925

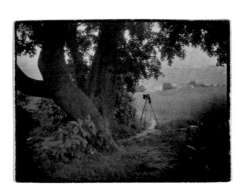

2 Country Accident, Esztergom, Hungary, 1916

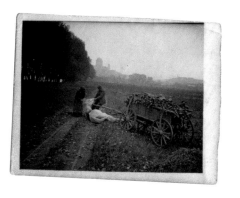

3 Untitled, 1916

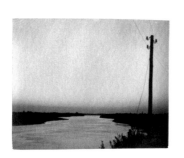

4 Untitled

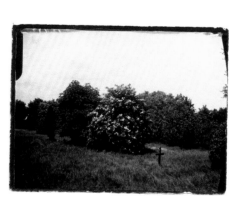

5 Esztergom, 1918

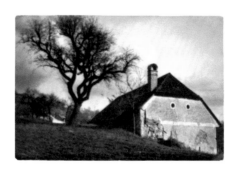

6 Untitled, September 1, 1919

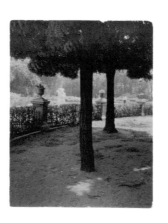

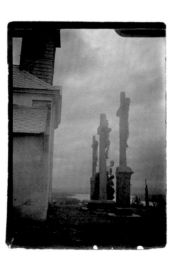

8 Untitled, August 30, 1922

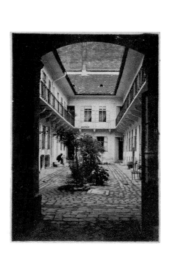

9 Untitled

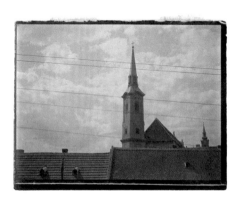

10 Bocskay-tér, Budapest, 1914

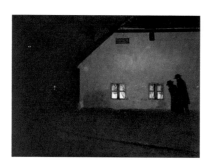

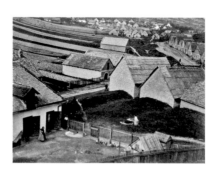

Self-portrait, Görz, 1914

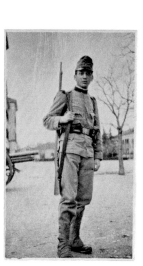

13 Forced March to the Front, Poland, July 26, 1915*

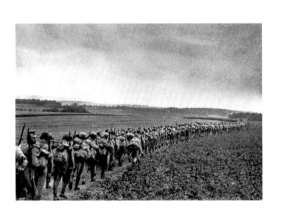

14 Untitled, October 1918

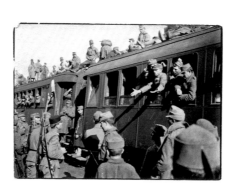

15 D. Minna Horn, July 26, 1918

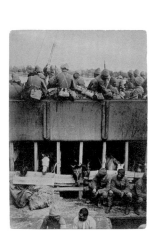

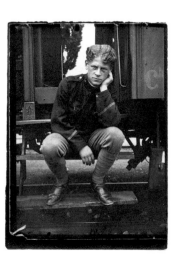

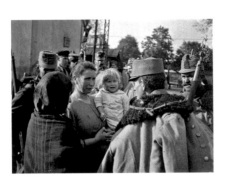

18 Accordionist, Esztergom, Hungary, October 20, 1916

19 Untitled, 1914–1918

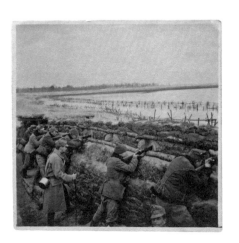

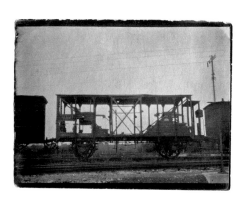

21 Untitled, October 20, 1920

22 Untitled, 1915

23 Soldier Fishing, 1914–1918

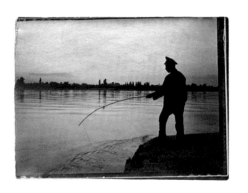

24 Before Going to the Front, Hungary, 1916

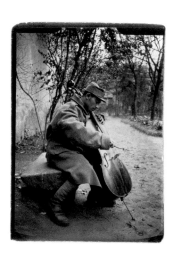

25 Myself and My Albanian Friends, Albania, 1918

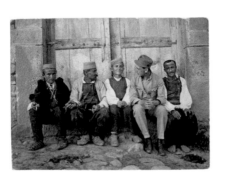

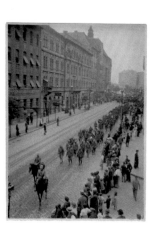

27 Untitled, 1914–1918

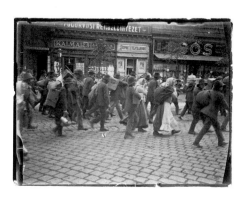

28 Underwater Swimmer, Esztergom, Hungary, 1917

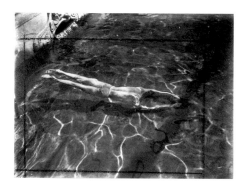

29 Untitled

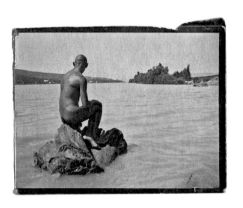

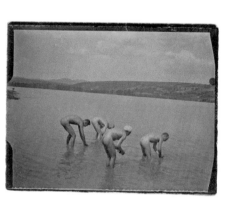

31 Jenő Kertész, Dunaharaszti, Hungary, 1919–1925

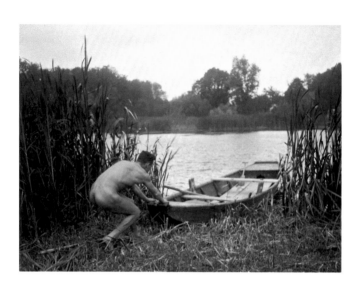

32 Self-portrait with My Brother, Hungary, 1919

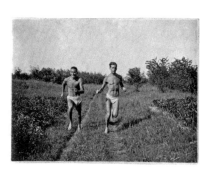

33 Imre and Jenő Kertész, 1919

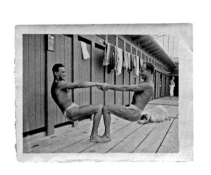

34 Untitled

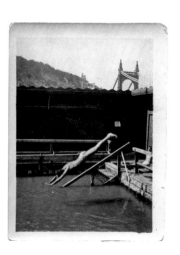

35 Self-portrait with Elizabeth Salamon, June 7, 1921

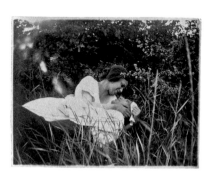

36 Albania, July 23, 1921

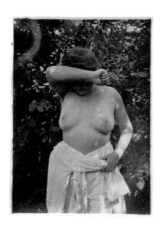

37 Lovers, Budapest, Hungary, 1915

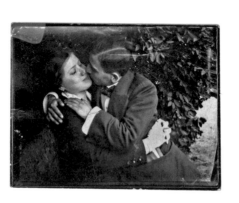

38 Untitled

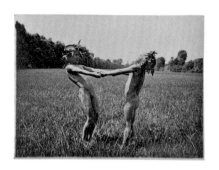

39 Jenő Kertész, September 21, 1919

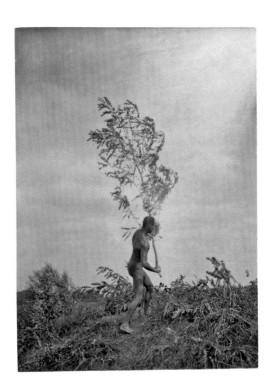

40 Jenő Kertész, 1919–1924

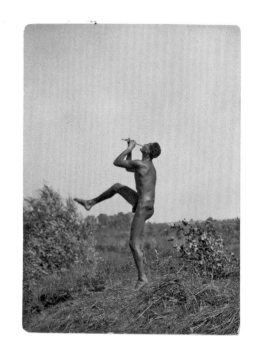

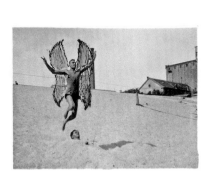

42　My Brother as a *Scherzo*, Hungary, June, 1919

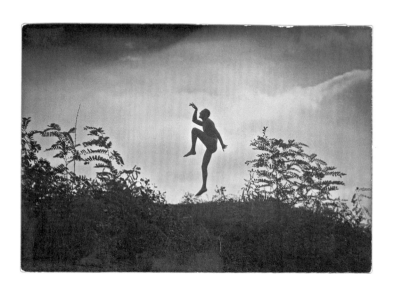

43 Jenő Kertész, 1919–1924

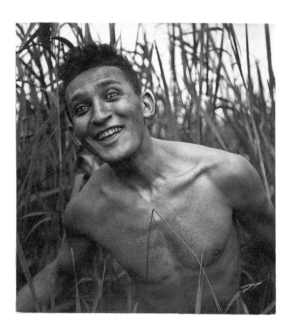

44 Jenő Kertész, 1919–1924

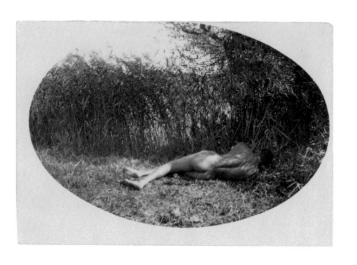

45 Circus, May 19, 1920*

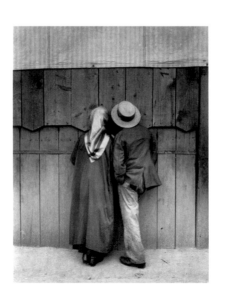

46 Wandering Violinist, Albania, Hungary, July 19, 1921

47 Self-portrait with Ede Papszt, 1921

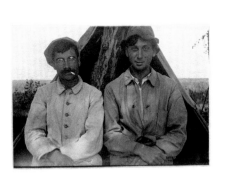

48 Children Reading, Esztergom, Hungary, 1915

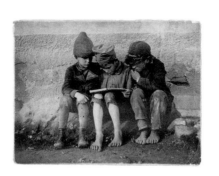

49 Sleeping Boy, Budapest, Hungary, 1912

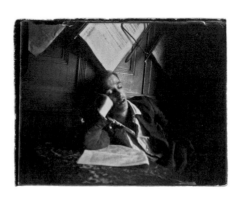

50 Népliget, Budapest, 1918

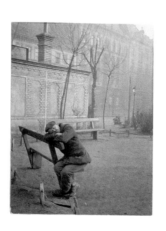

51 | Hazy Day, November 19, 1920*

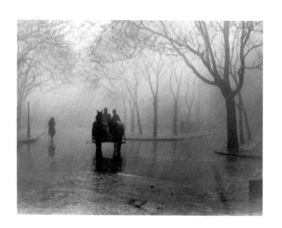

52 Sweeping Downtown, Esztergom, Hungary, February 1, 1917

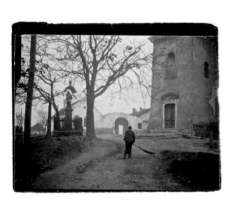

53 Nuns in a Cemetery, February 20, 1920

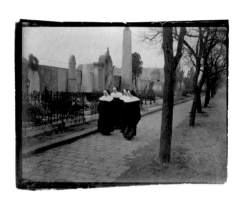

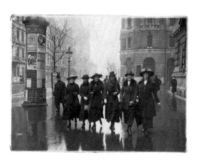

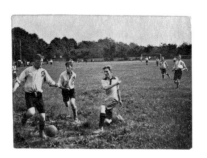

56 Jenő Kertész, November 13, 1921

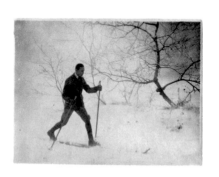

57 Untitled, November 13, 1921

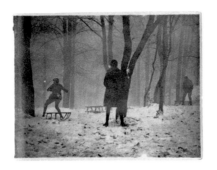

58　A Real Ruffian

59 Imre and Jenő Kertész, March 6, 1919

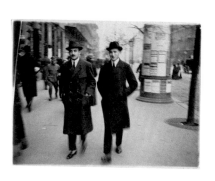

60 Gyula Zilzer, December 11, 1921

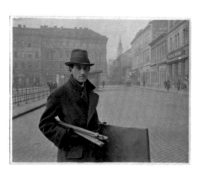

61 Untitled, 1916

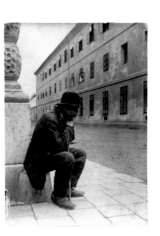

62 Untitled self-portrait with Elizabeth, March 27, 1921

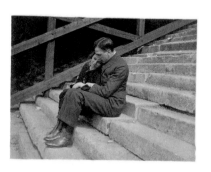

63 Untitled Portrait of Imre Kertész

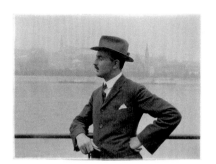

Budapest, Hungary, 1914

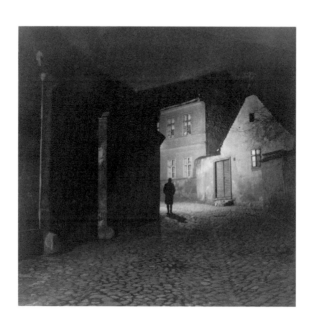

65 Elizabeth Drawing on a Street Poster, April 27, 1920

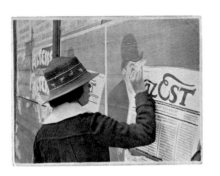

66 Elizabeth and Me, Budapest, Hungary, October 7, 1920

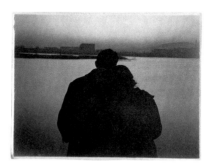

ACKNOWLEDGMENTS

Silverstein Photography gratefully acknowledges Jose Fernandez and Alex Hollender, the executors of the Estate of André Kertész, for their role in preserving the works included in this publication, Jim Mairs, editor, W. W. Norton, for his vision and foresight in bringing this extraordinary project to fruition, and Tamas Revesz, whose considerable prepress preparation and printing expertise were tested and validated in the reproduction of each of these plates, as well as gallery intern Sarah Lappé for her assistance. Thanks to Don Kennison for his careful copyediting and to Laura Lindgren, who went above and beyond the call of duty in creating the beautiful design of this book.

 Silverstein Photography also extends its sincerest gratitude to Robert Gurbo, curator of the Estate of André Kertész, for his undeniable vision and indefatigable commitment to the legacy of André Kertész.

 Robert Gurbo would like to thank Bruce Silverstein for having the insight and conviction to pursue this project dedicated to Kertész's neglected early work, as well as Kim Bourus, whose long hours of dedication and quiet sense of humor kept this project moving along. He would like to acknowledge Sarah Greenough, curator, and Sarah Kennel, assistant curator, of the photography

department at the National Gallery of Art, Washington, D.C. Their exhaustive research and essays for the exhibition catalogue *André Kertész* resulted in an invaluable source of information. He would also like to thank Oliver Botar, whose essay in *Tibor Pólya and the Group of Seven: Hungarian Art in Toronto Collections 1900–1949* first brought to light Kertész's interaction with Hungarian artists after World War I. Thanks, too, to good friend Sándor Szilágyi, who is always willing to drop everything to research facts and discuss ideas, and Sarah Morthland, for her constant support and insightful edits.

Robert would also like to express his love and appreciation to his wife, Louise Voccoli, and their sons, Victor and Joseph, for their support during this project.

His deep gratitude goes to Paul Berlanga, text editor, for the loopy conversations at two a.m. Paul's understanding of André Kertész's art and the written word has gracefully enhanced the essay.

Mostly he would like to thank André Kertész, whose visual poetry continues to surprise, inform, and entertain.

André Kertész: The Early Years
by Robert Gurbo
edited by Robert Gurbo and Bruce Silverstein

Production Editor
Kim Bourus, Director, Silverstein Photography

Text Editor for Robert Gurbo
Paul Berlanga

Book Design and Composition
Laura Lindgren

Prepress Preparation and Printing Supervision
Tamas Revesz

The text of this book is composed in
Cooper Old Style with the display in
AT Handle Oldstyle.

Manufacturing by Novoprint Rt. Hungary

This book accompanies an exhibition
held at Silverstein Photography, New York
October–November 2005

Silverstein Photography
535 West 24th Street
New York, New York 10011
Telephone: 212-627-3930
Fax: 212-691-5509
silversteinphotography.com

ISBN: 0-393-06160-4

W. W. Norton & Company, 500 Fifth Avenue,
New York, NY 10110
www.wwnorton.com

W. W. Norton & Company Ltd., Castle House,
75/76 Wells Street, London, WIT 3QT

1 2 3 4 5 6 7 8 9 0